30 MORE MANDALAS COLORING BOOK

Created by Angela Ronk DBA
TechneGraphix Graphic Design
www.TechneGraphix.com
Email: TechneGraphix@gmail.com

© 2016 Angela Ronk

Published by CreateSpace August 27, 2016
Williamsburg, Virginia

All Rights Reserved by Angela Ronk

DO NOT DUPLICATE, Doing so infringes on the
copyright that is owned by Angela Ronk

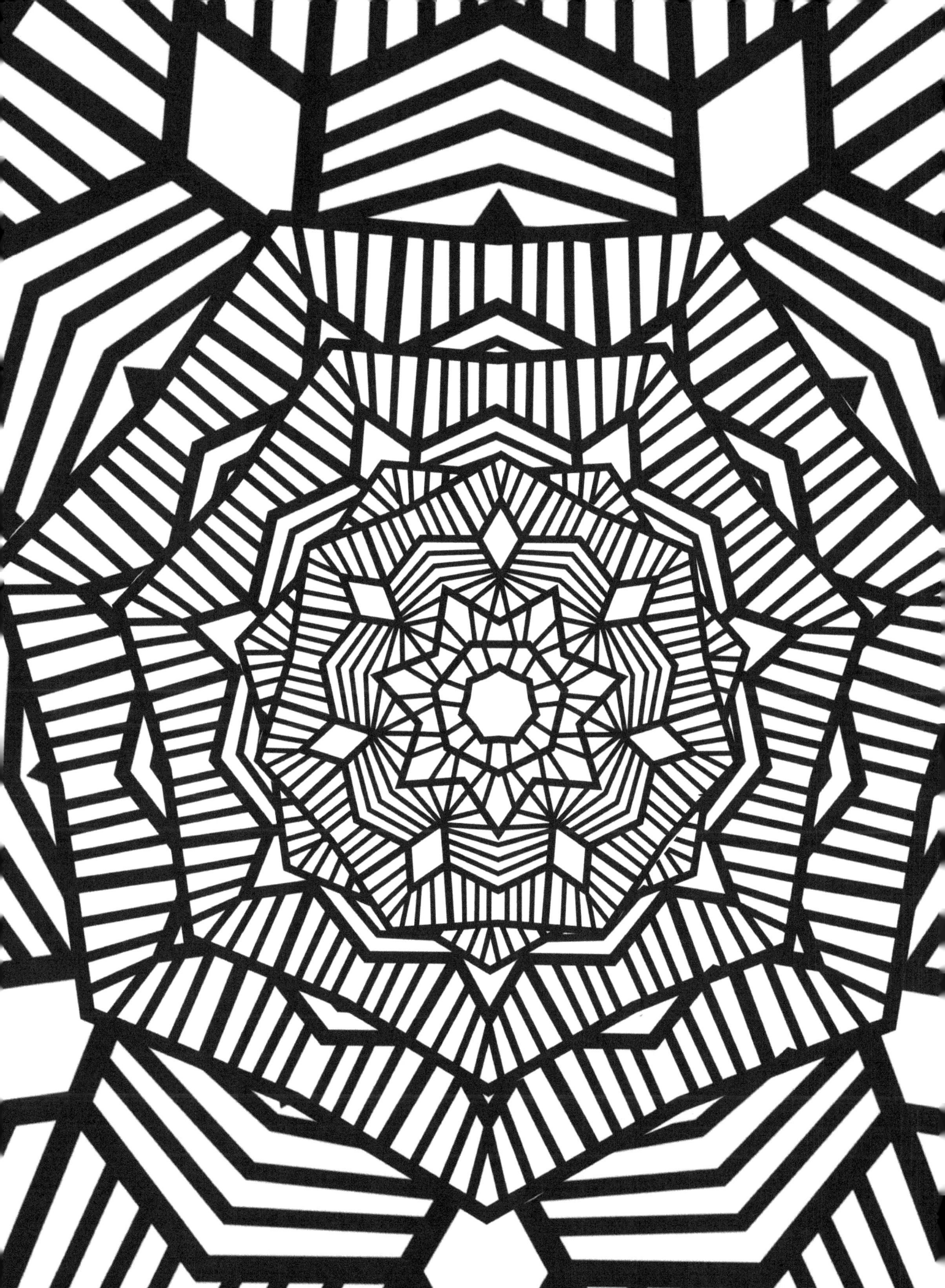

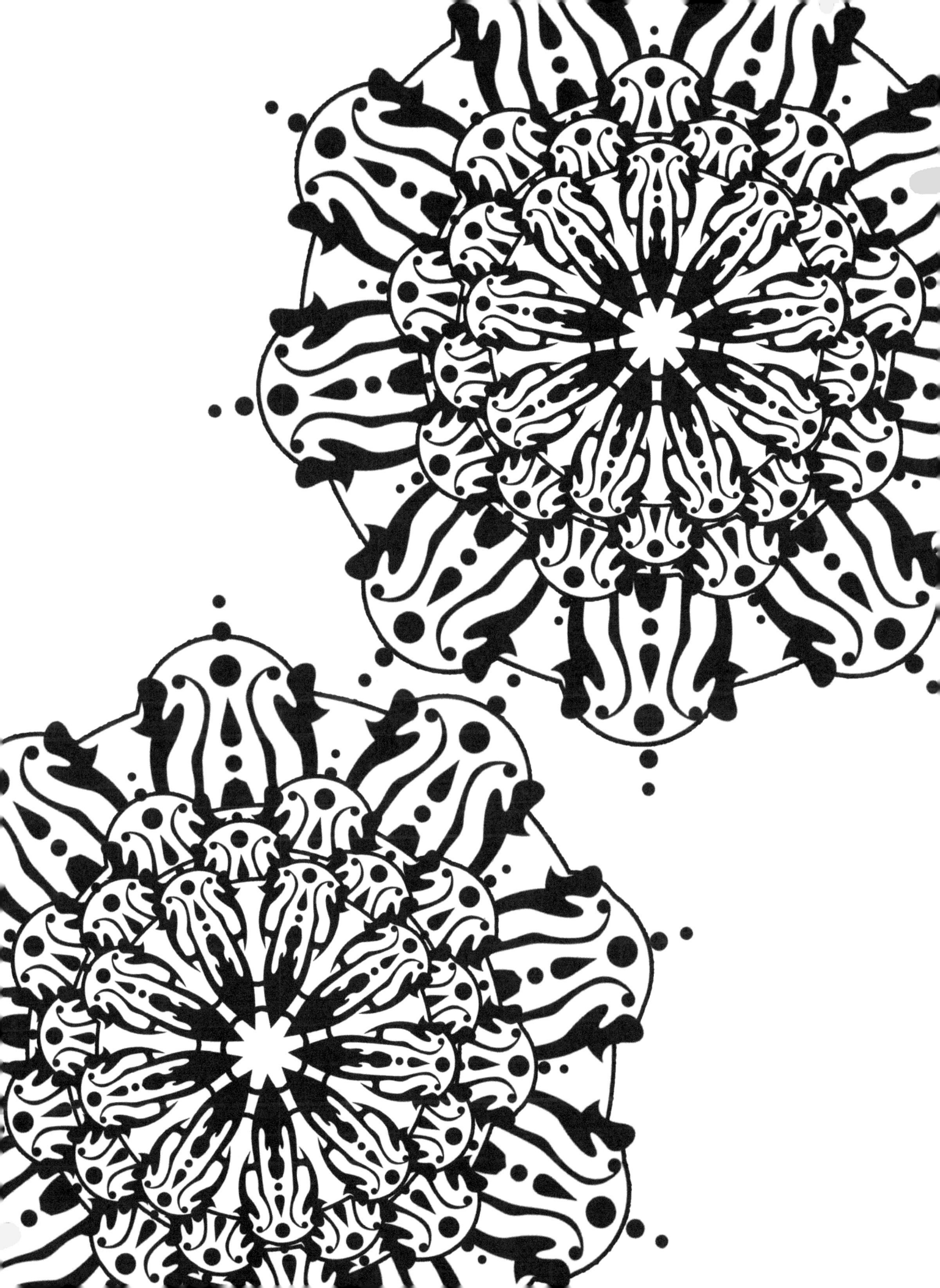

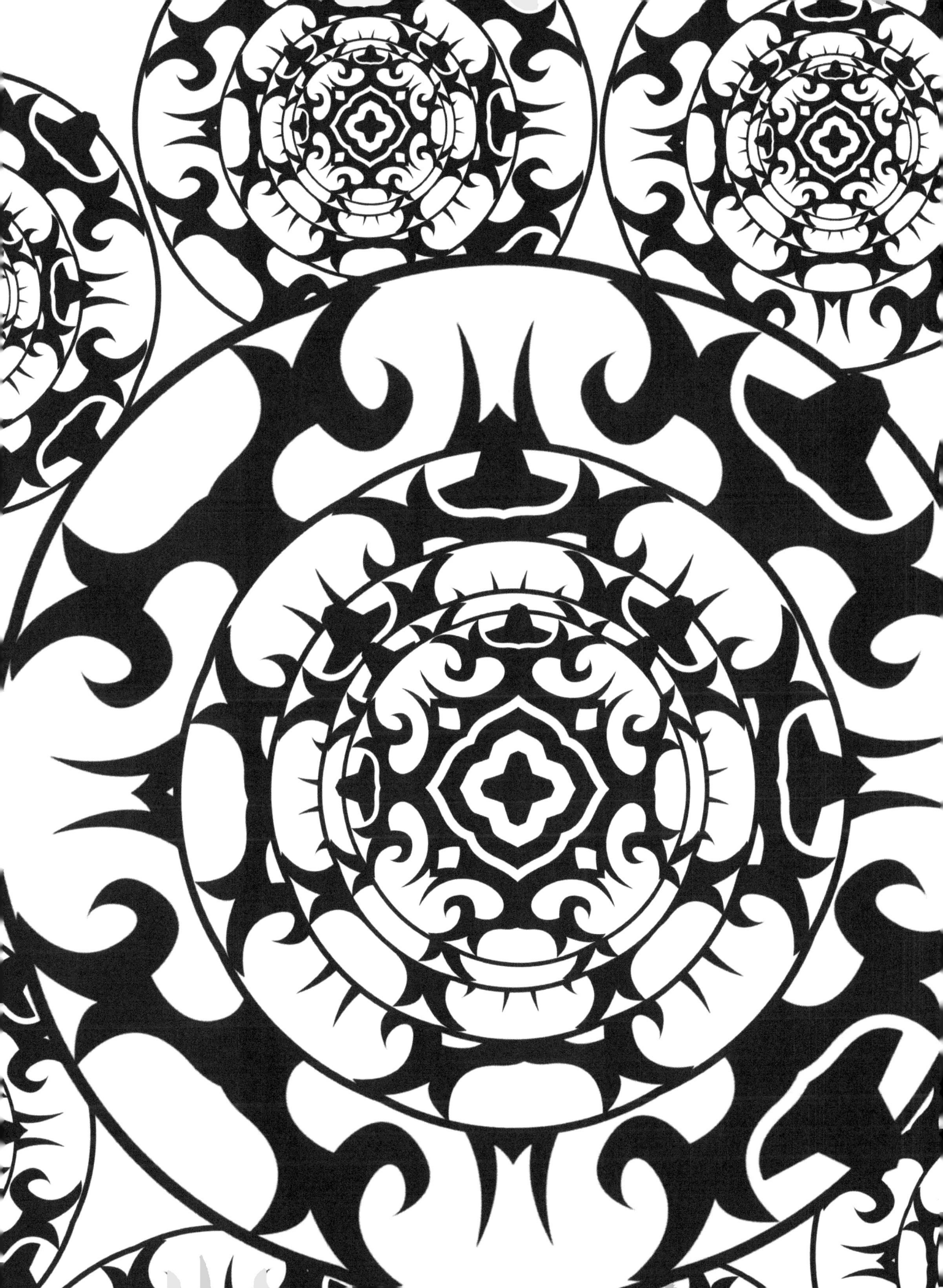

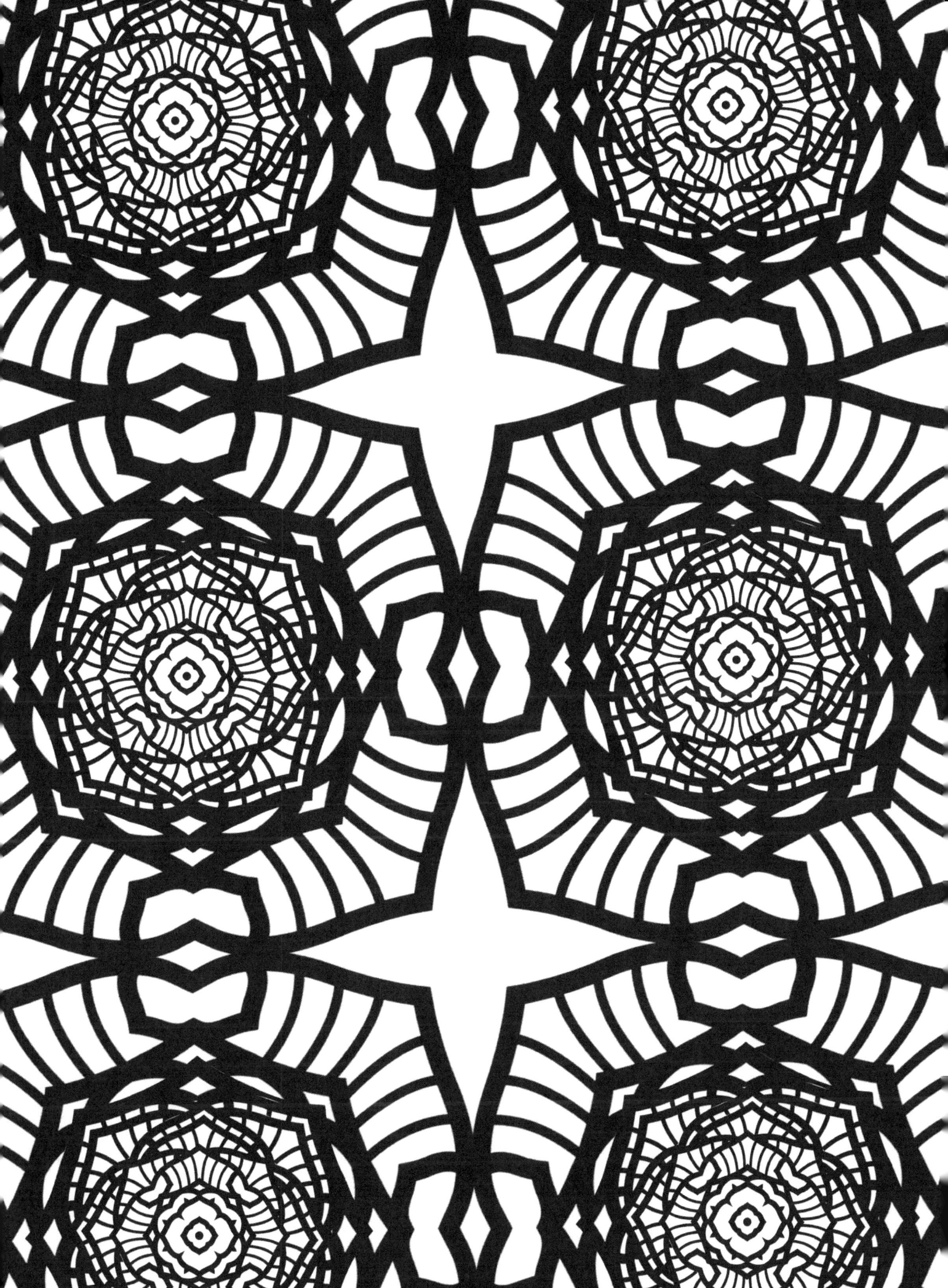

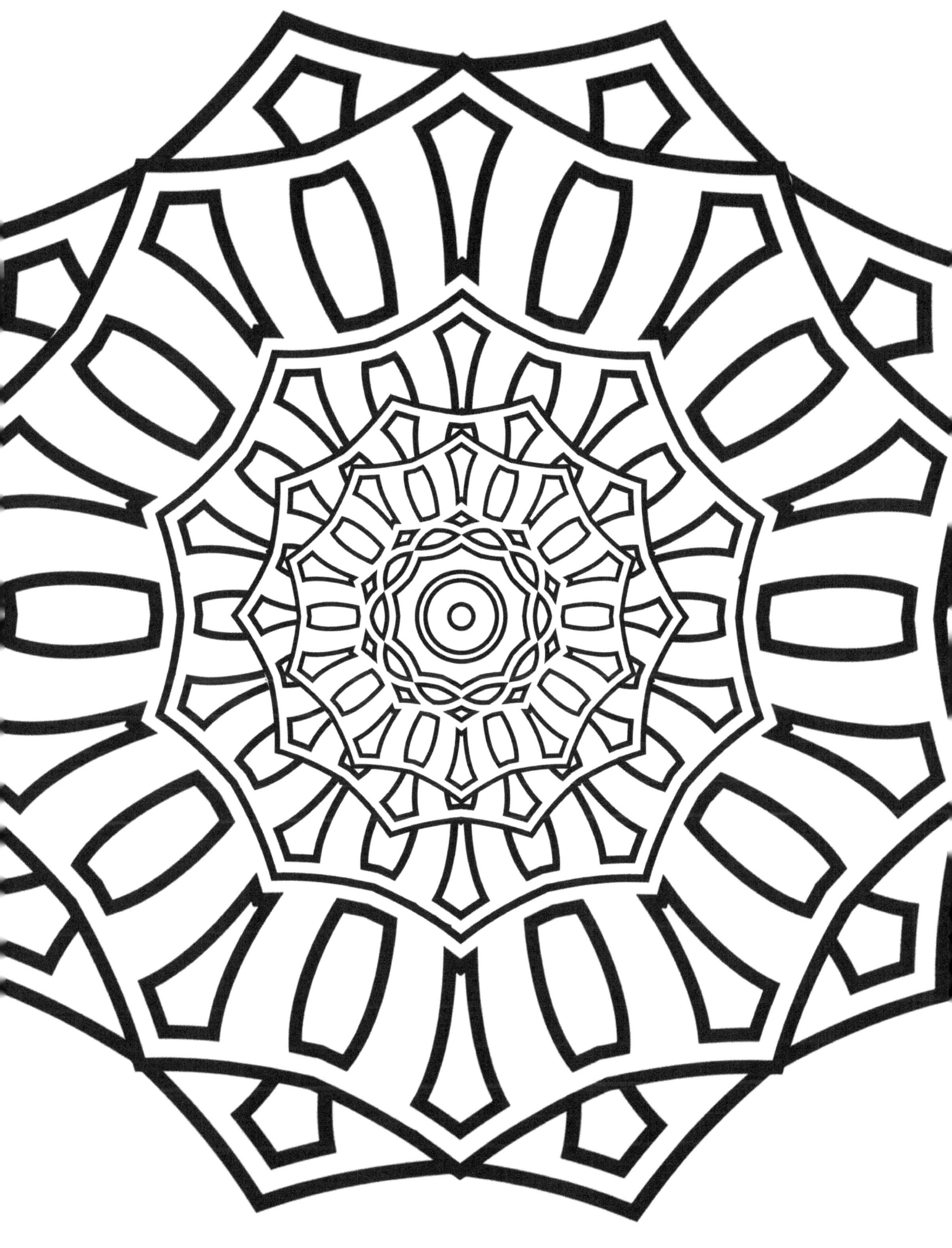

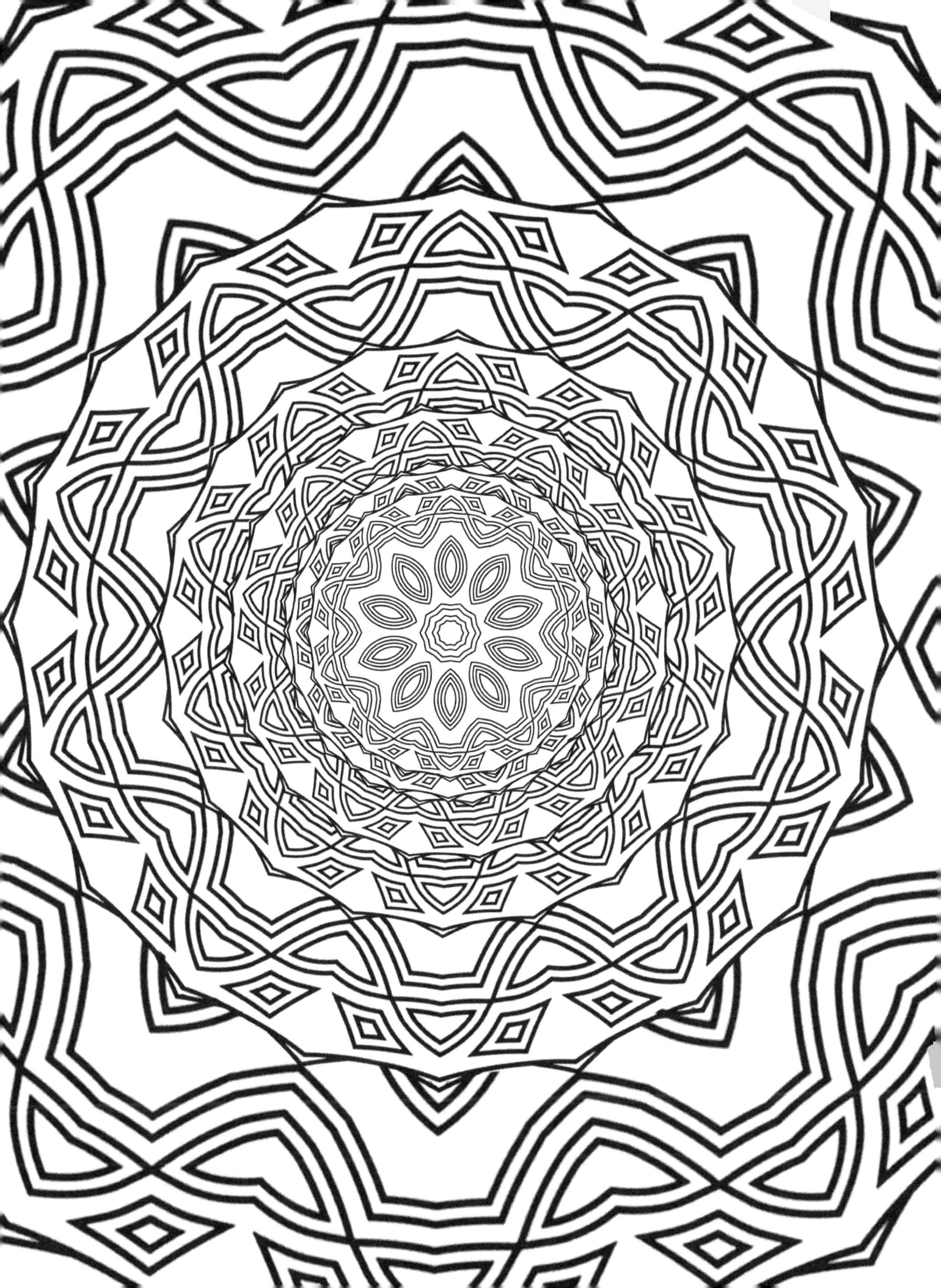

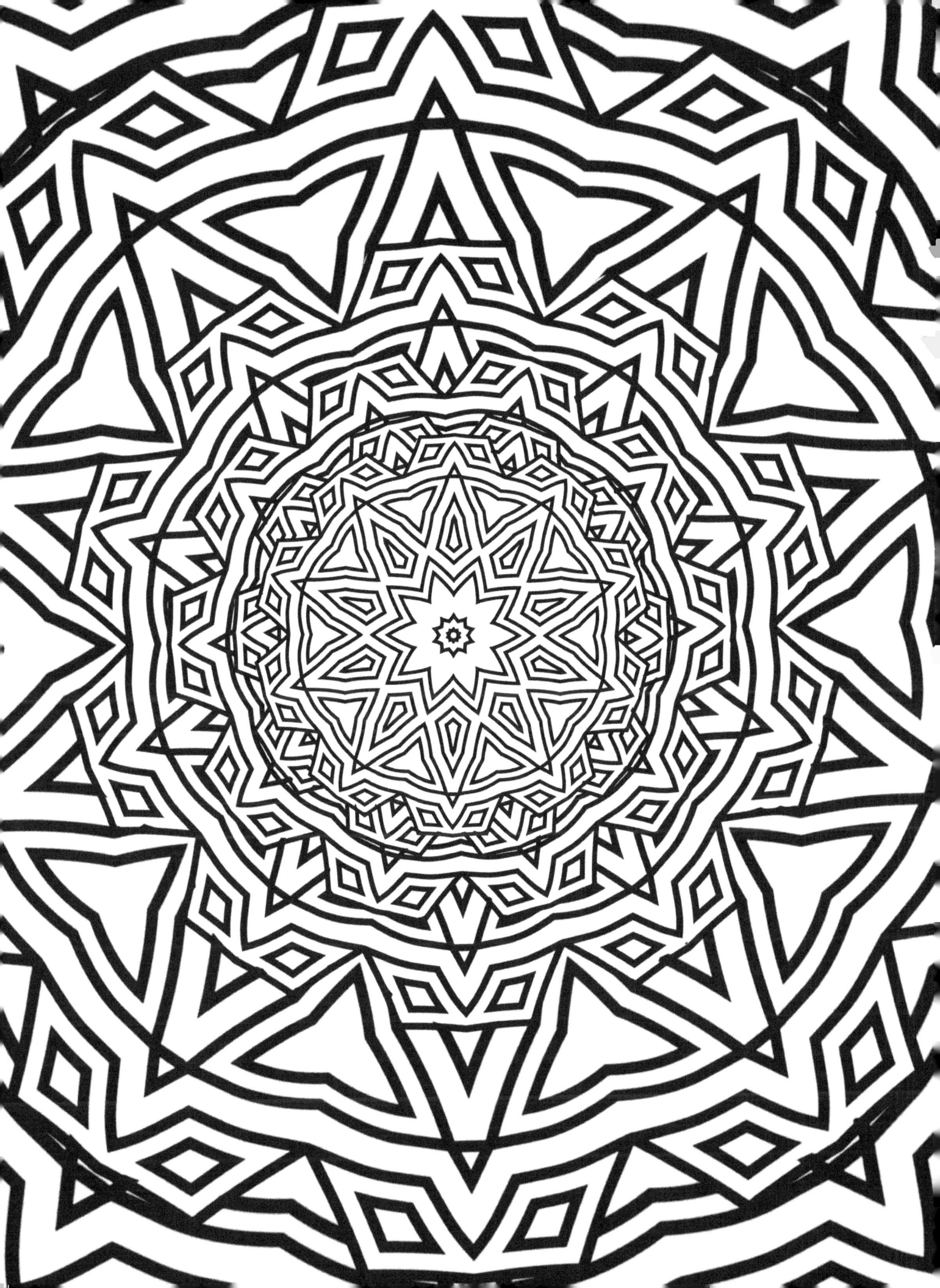

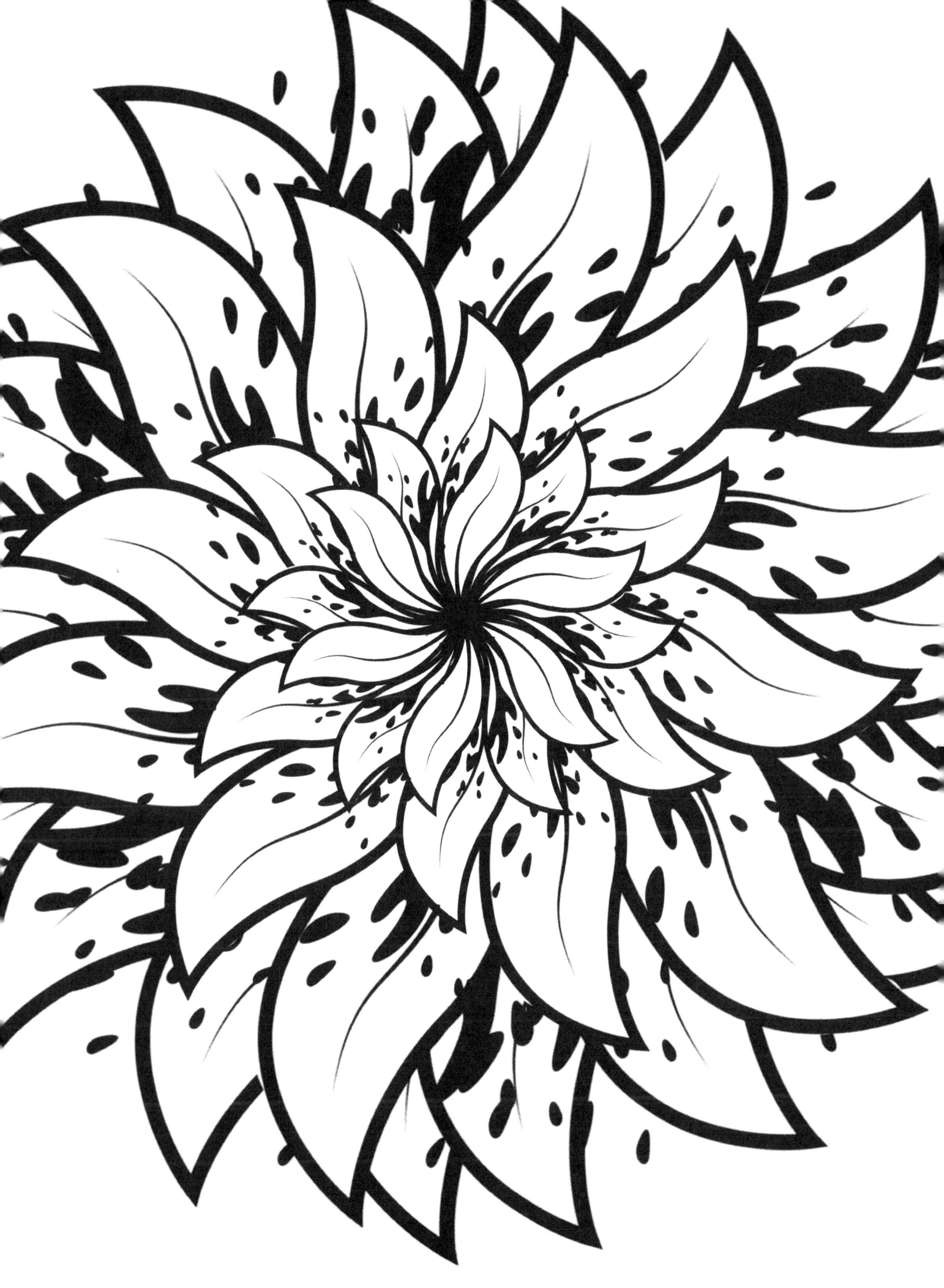

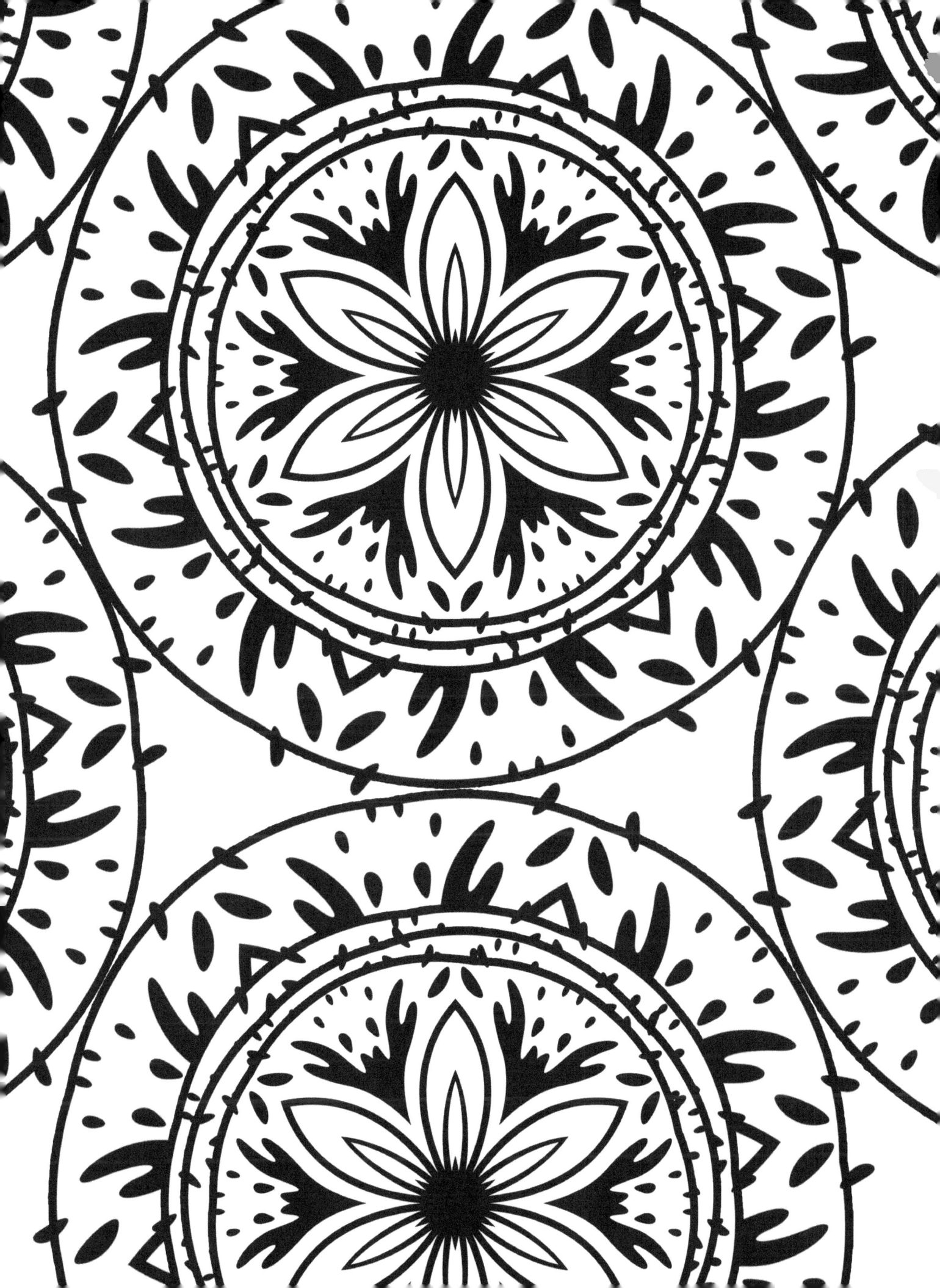

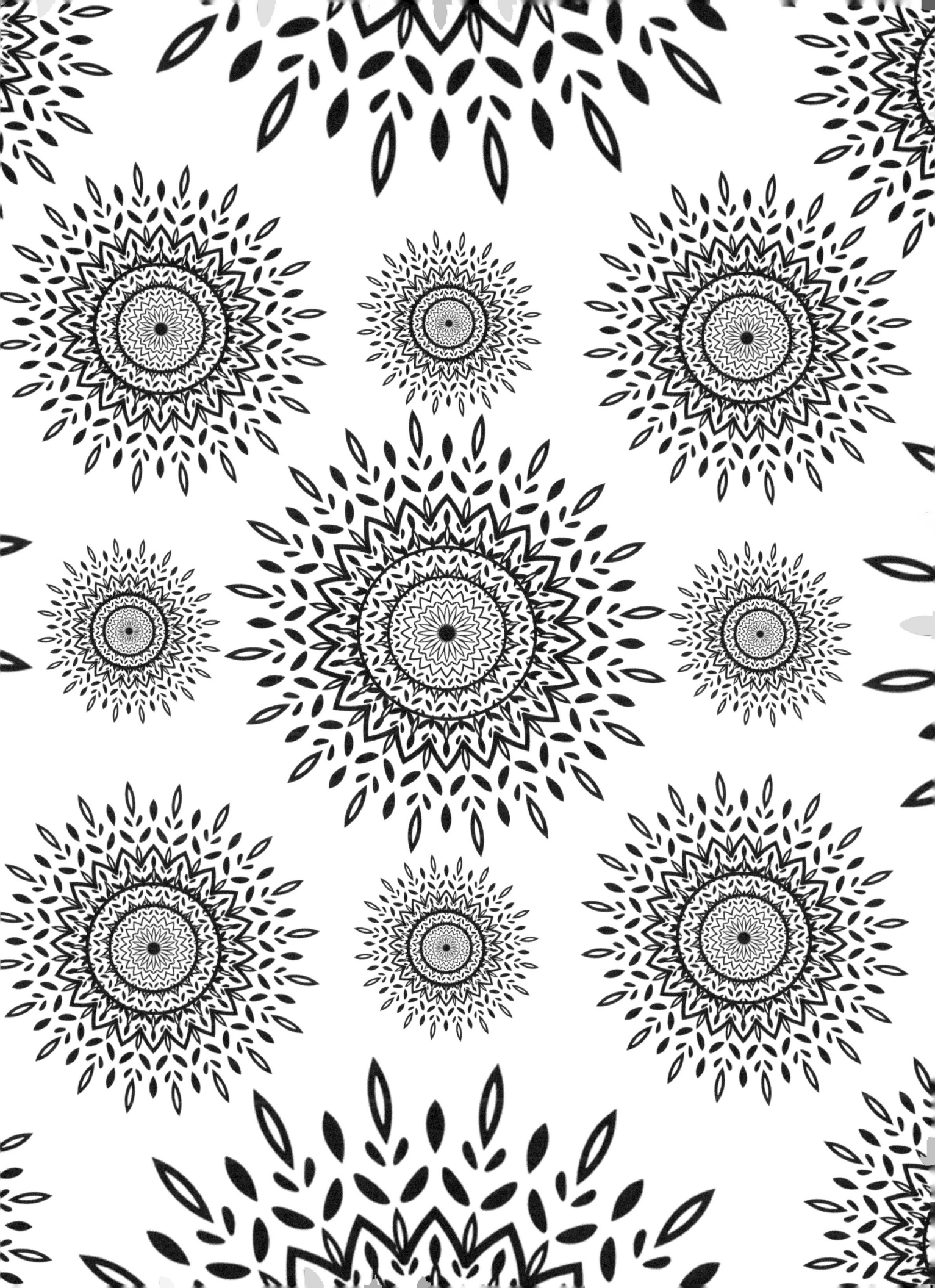

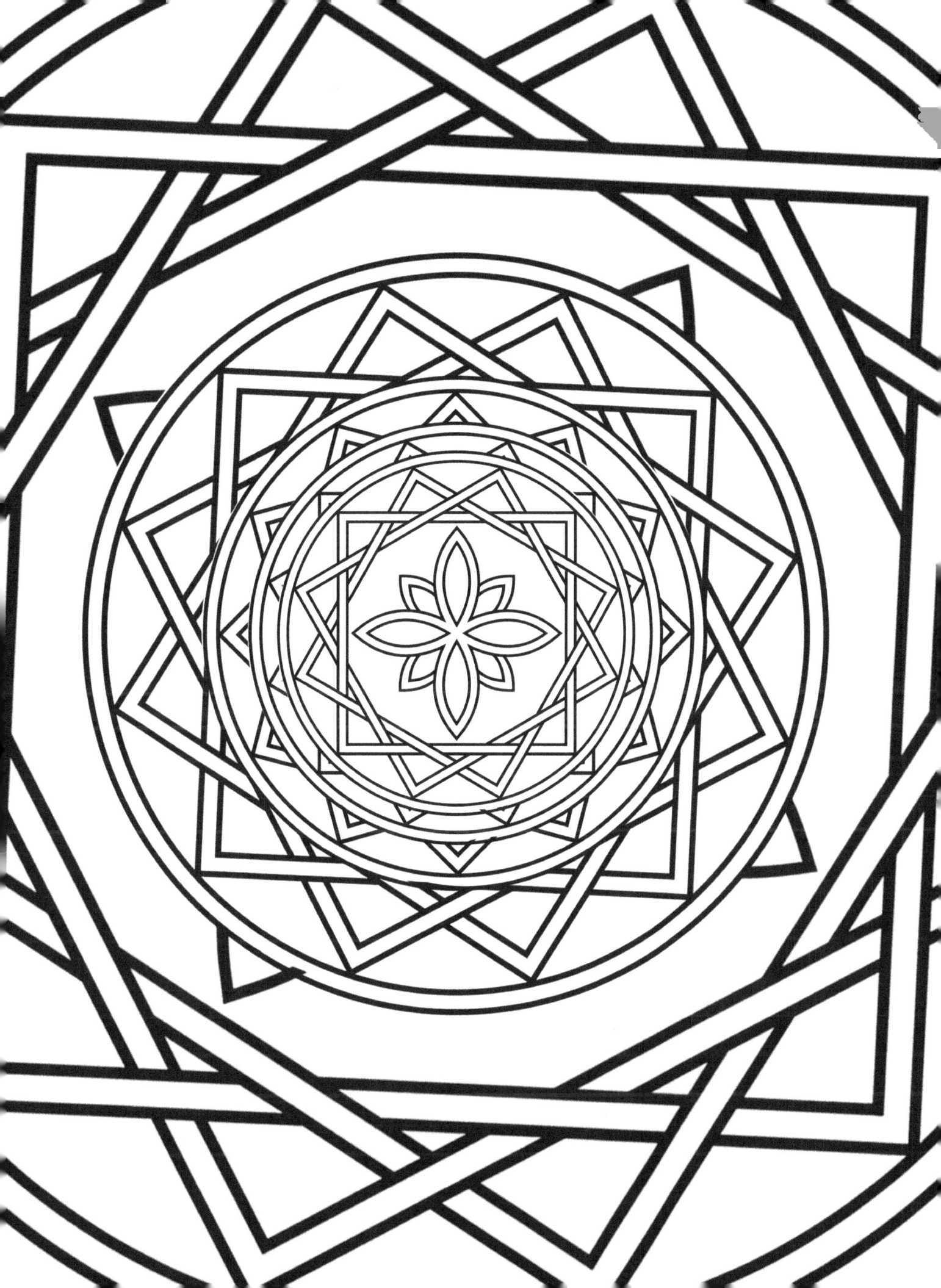

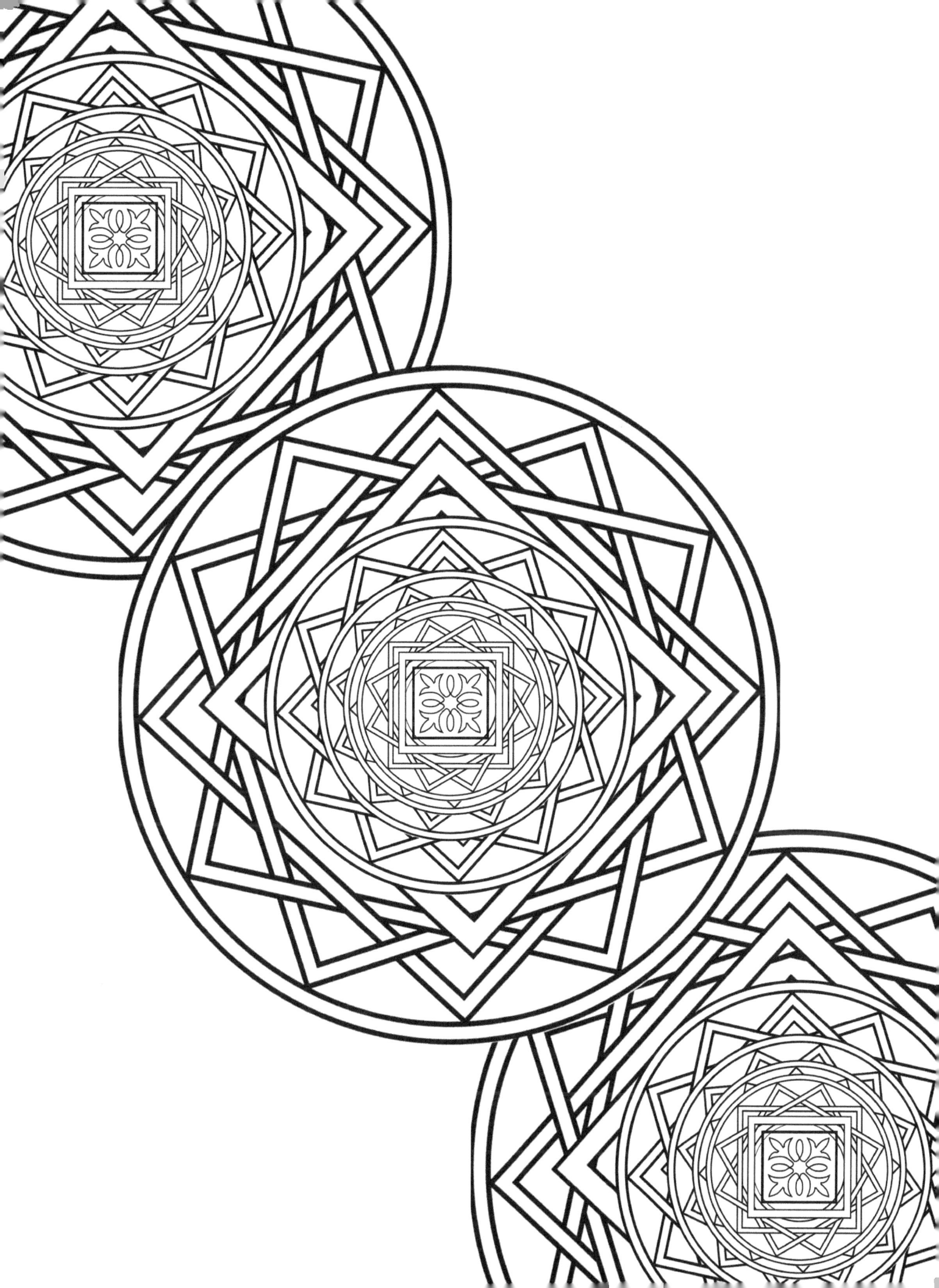

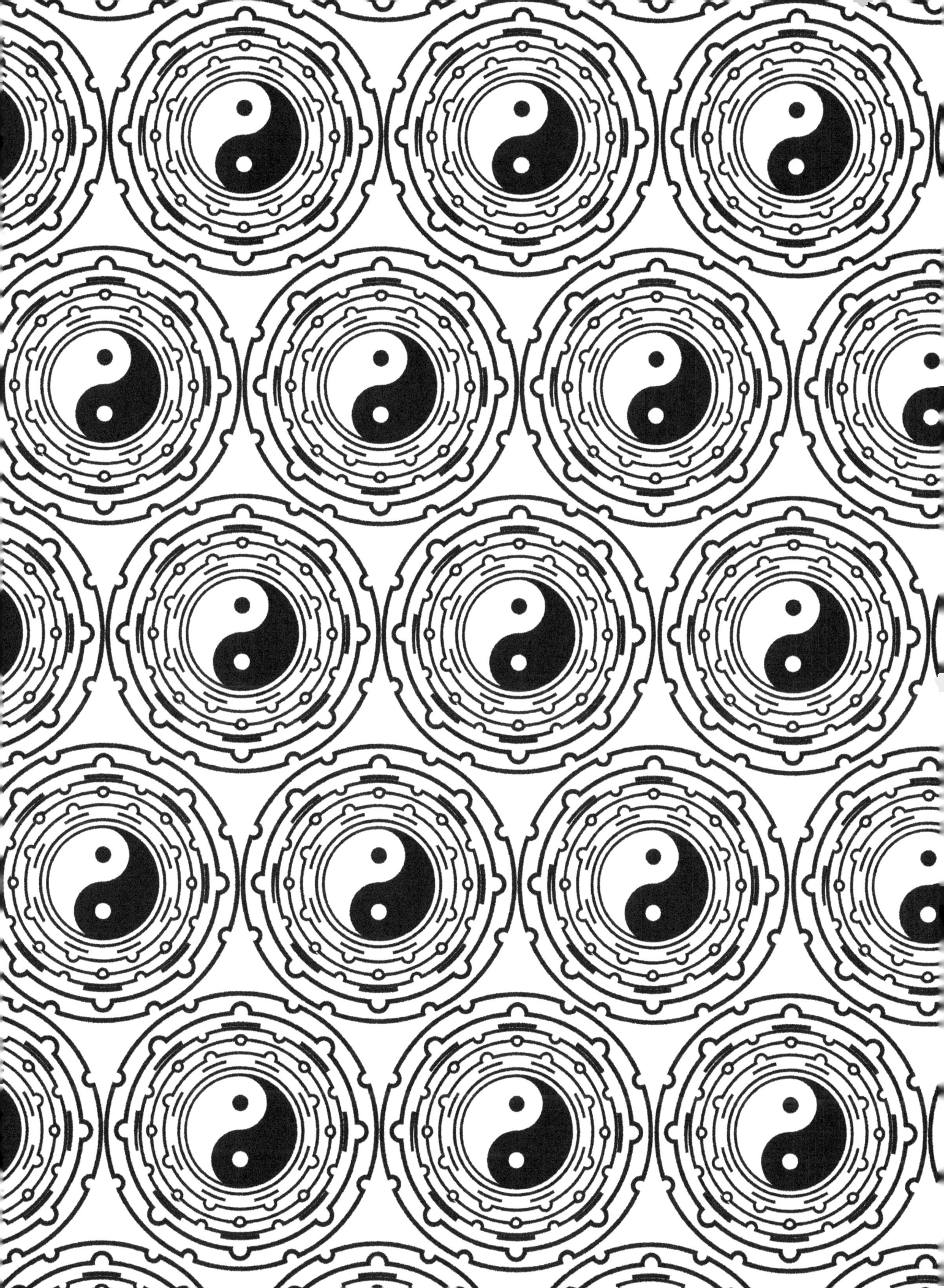

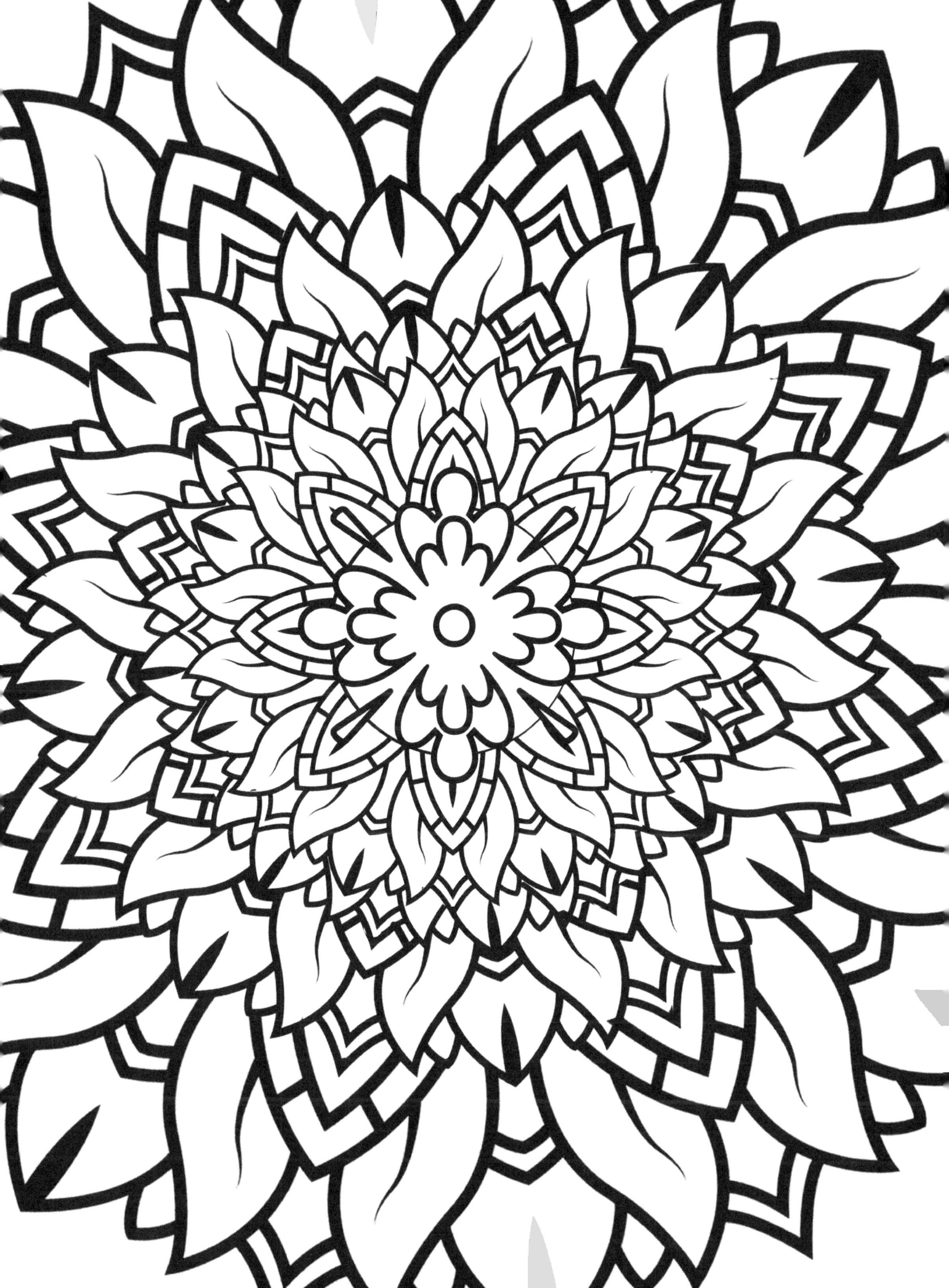

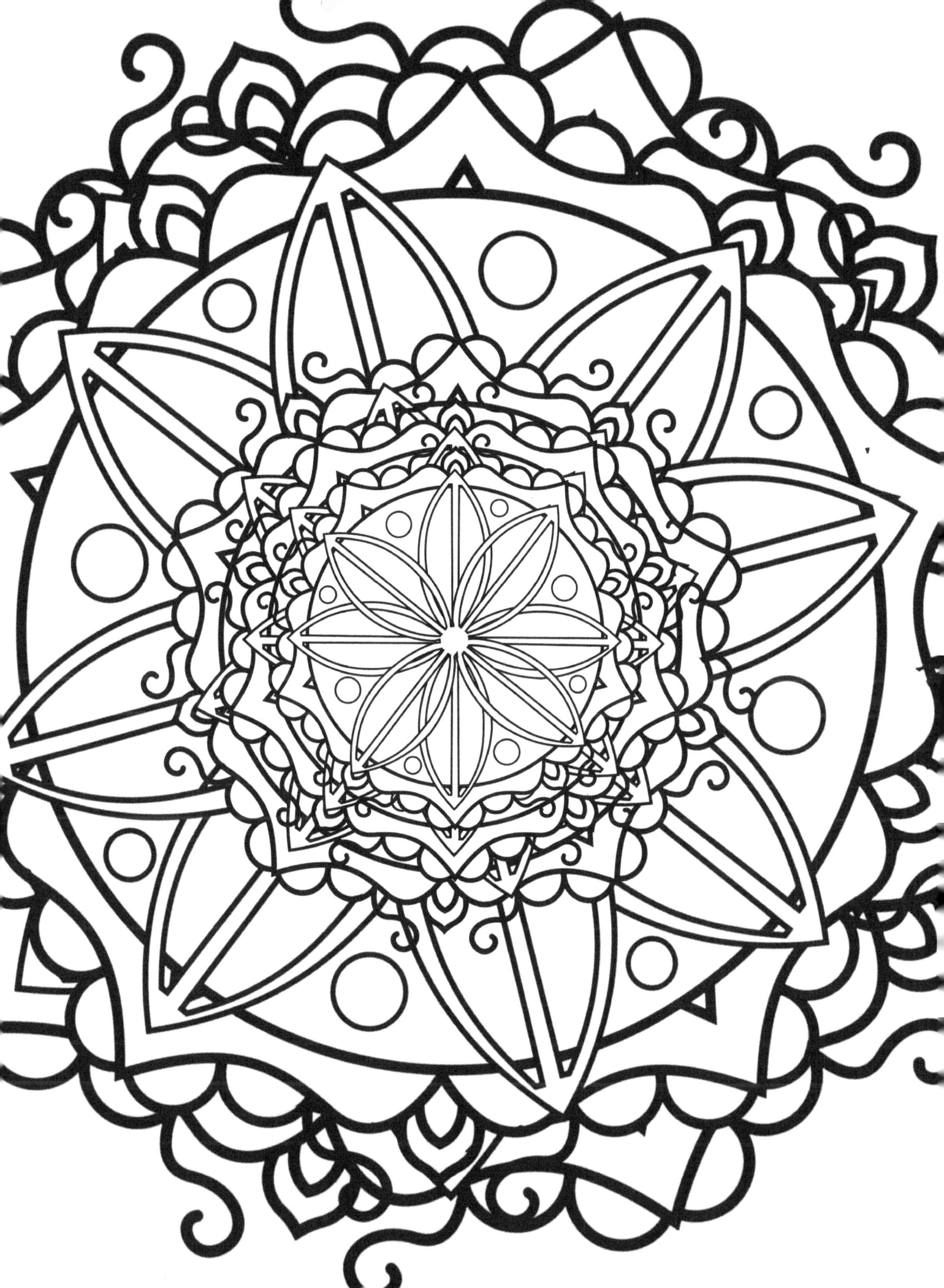

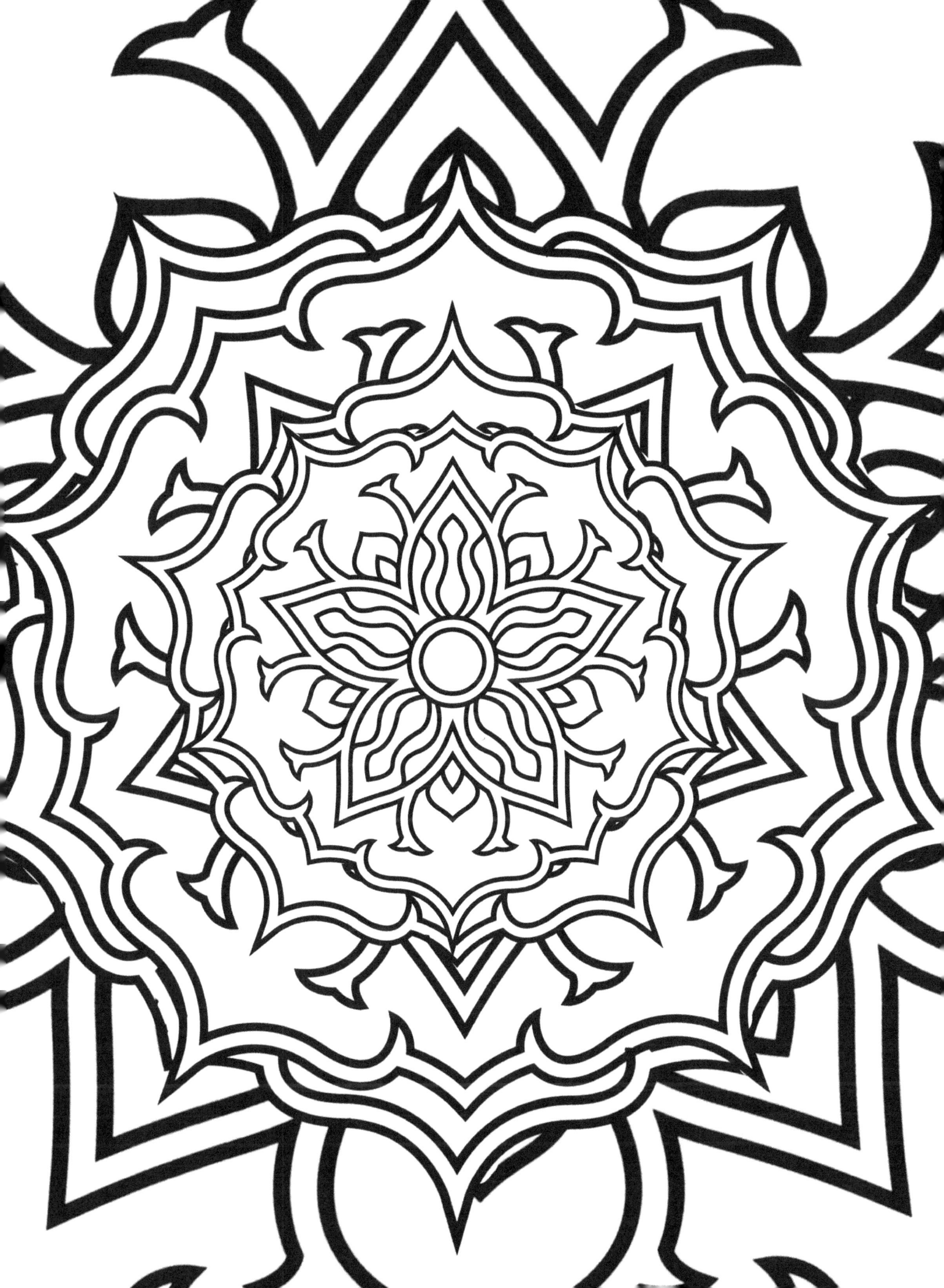

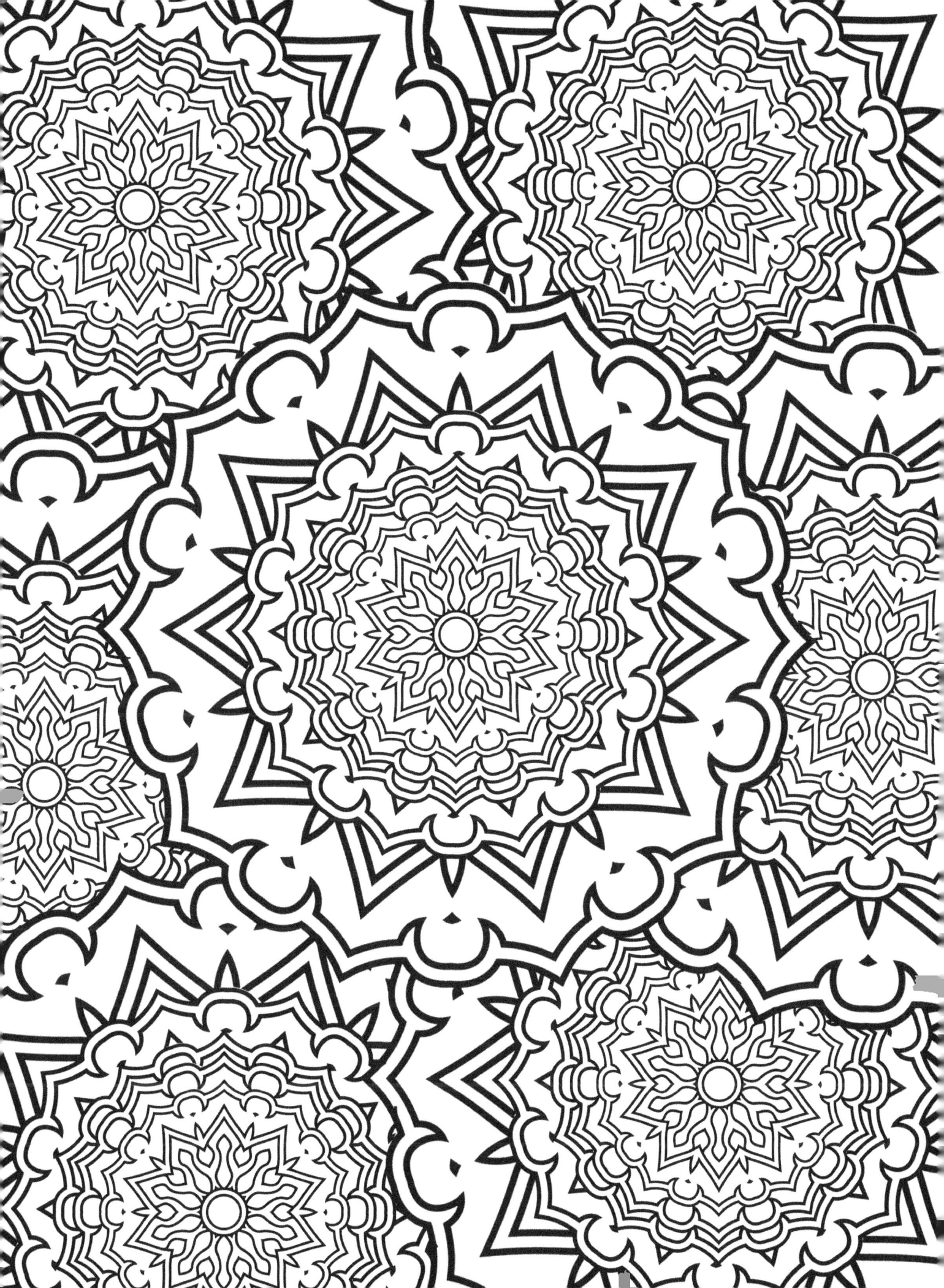

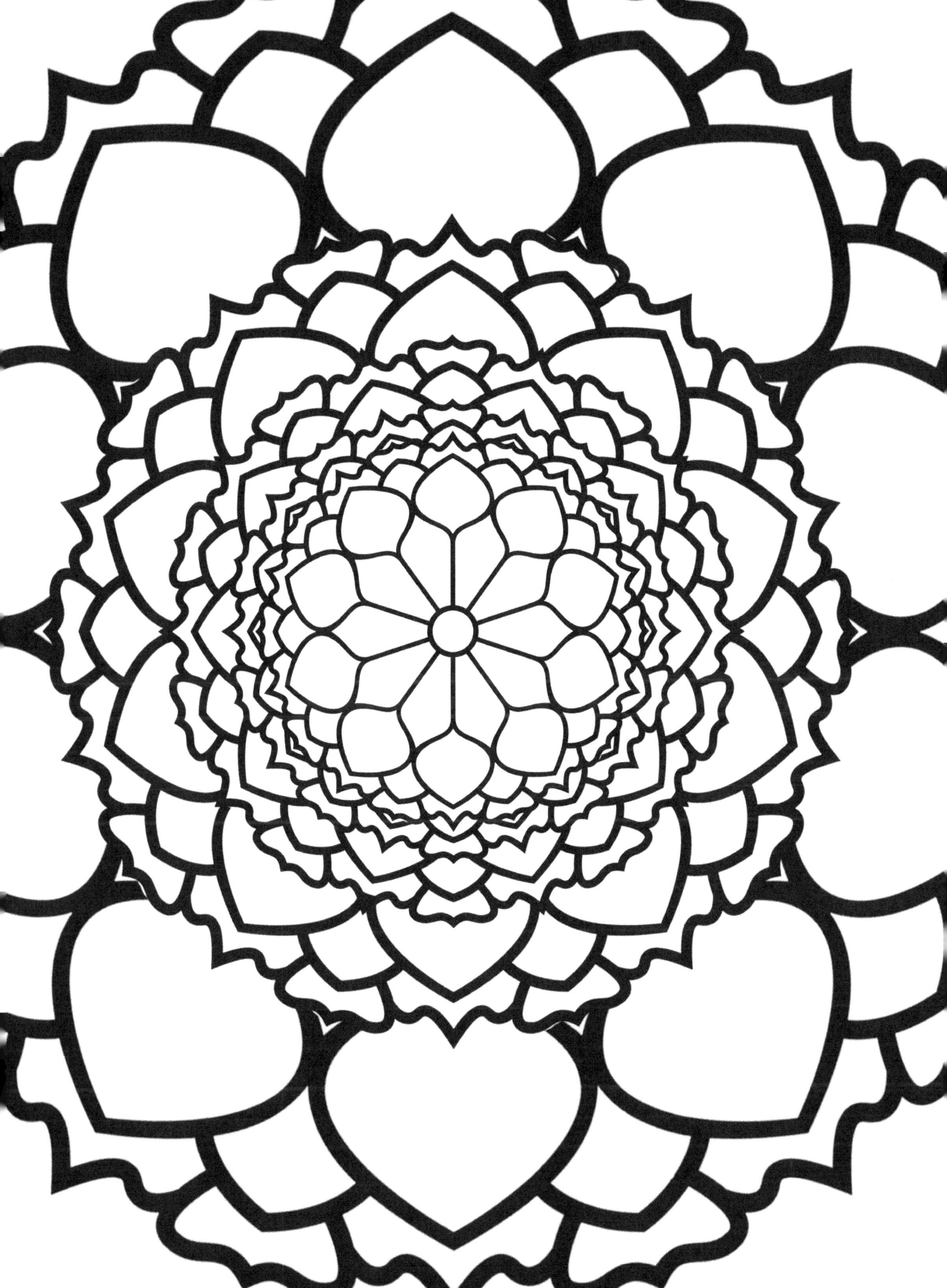

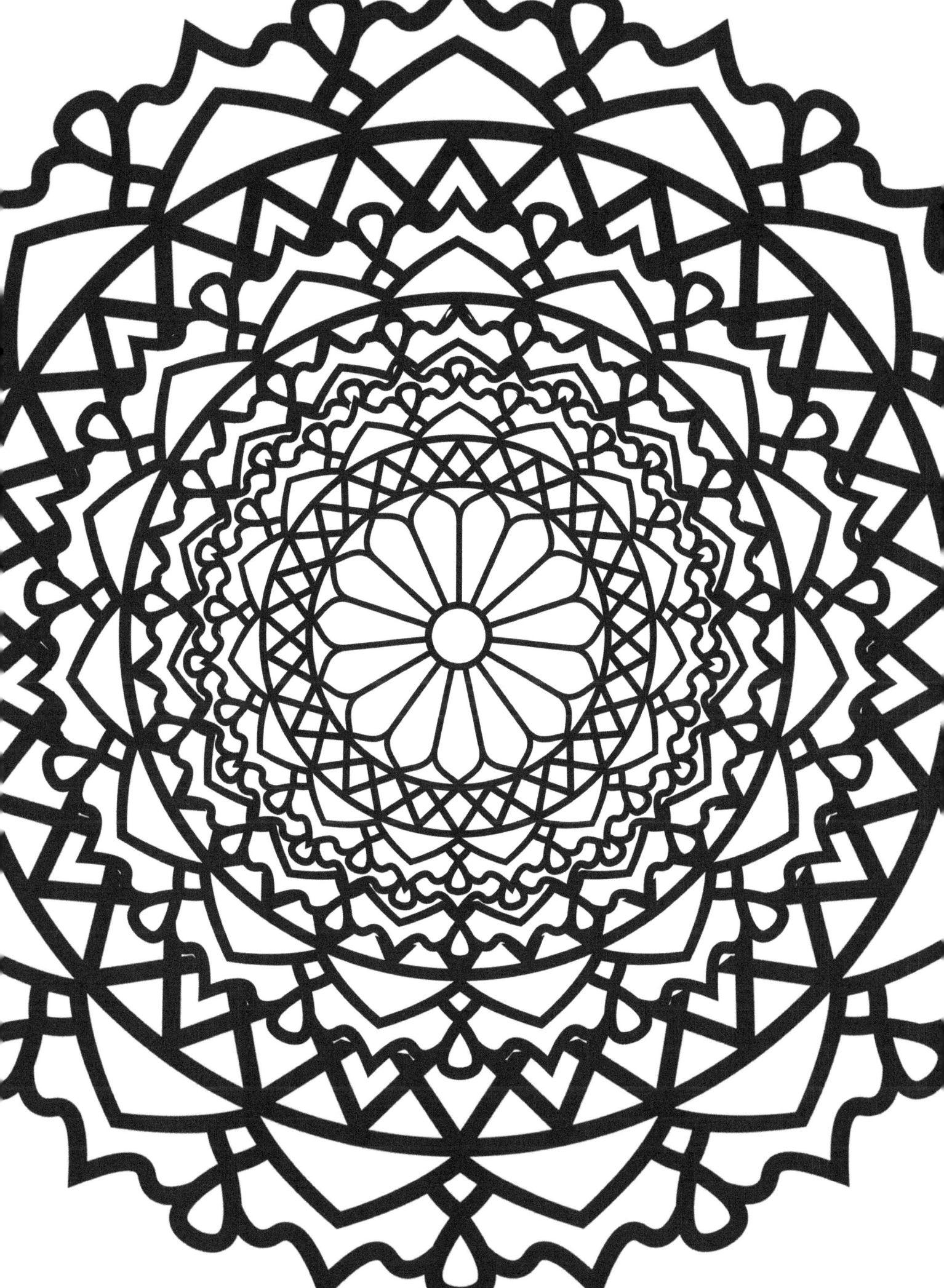

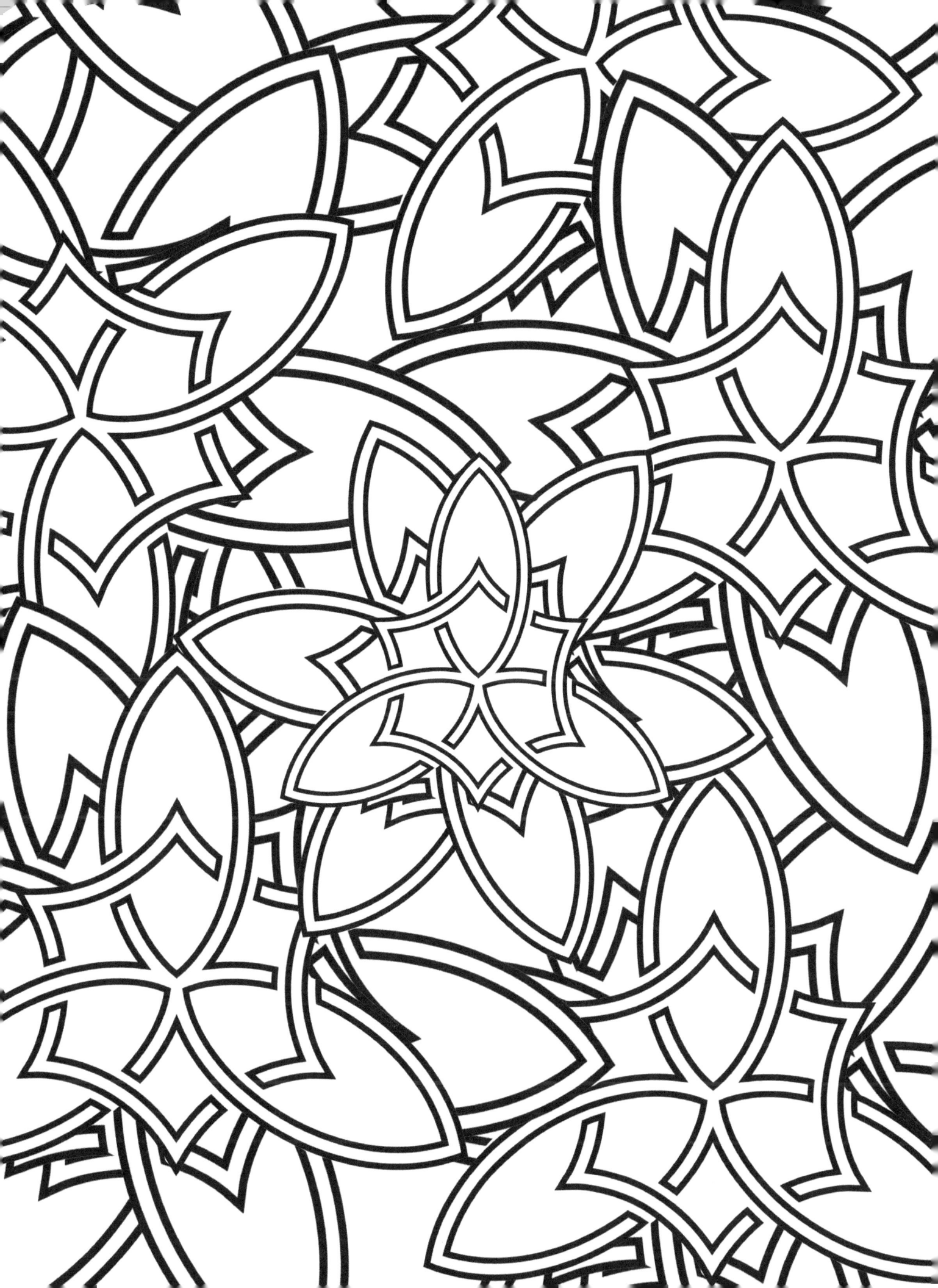

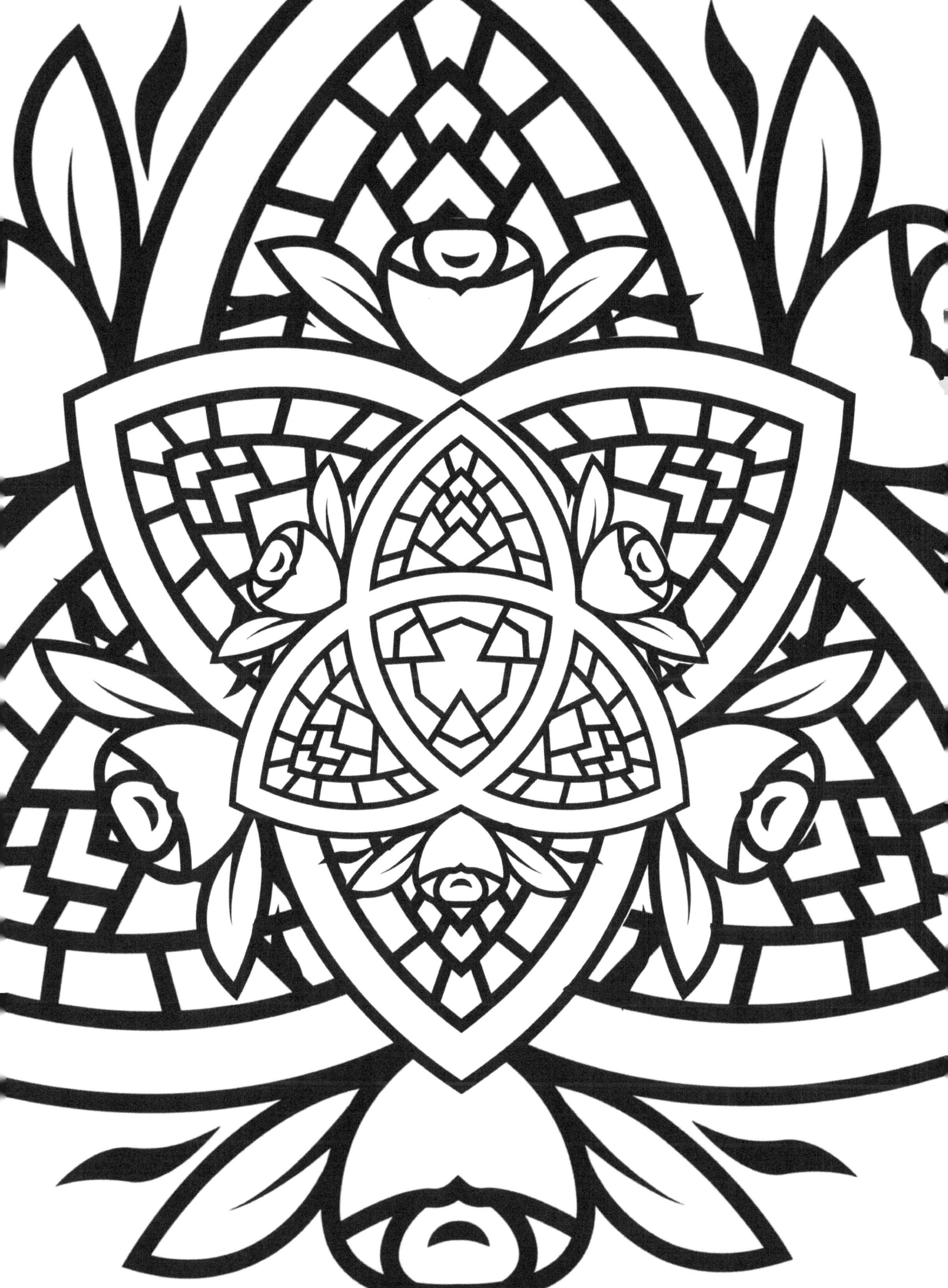

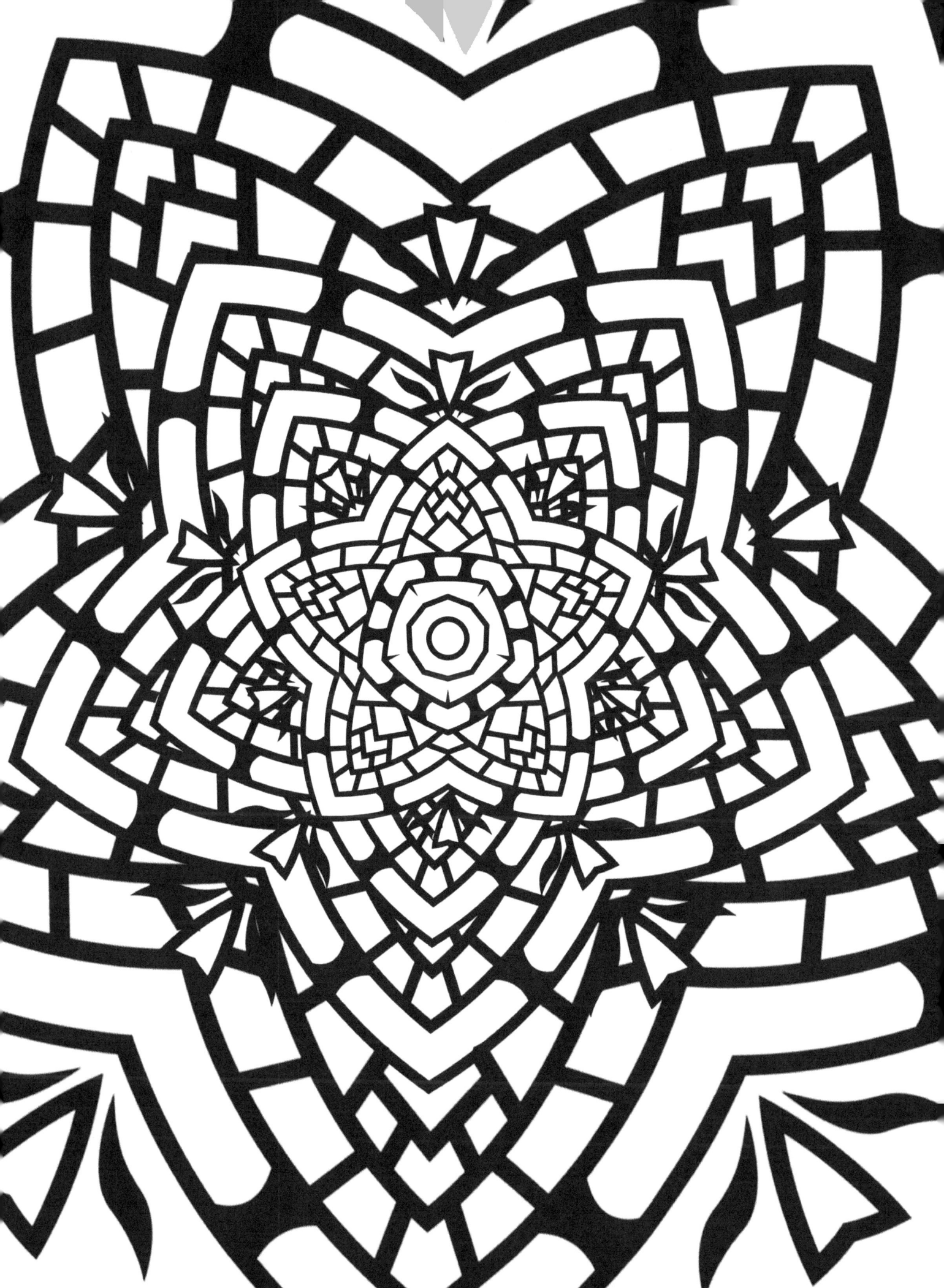

www.ingramcontent.com/pod-product-compliance
Lightning Source LLC
Chambersburg PA
CBHW080546190526
45169CB00007B/2657